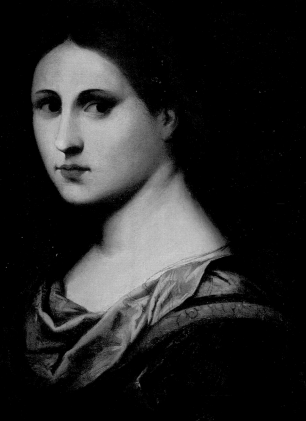

DANGEROUS WOMEN

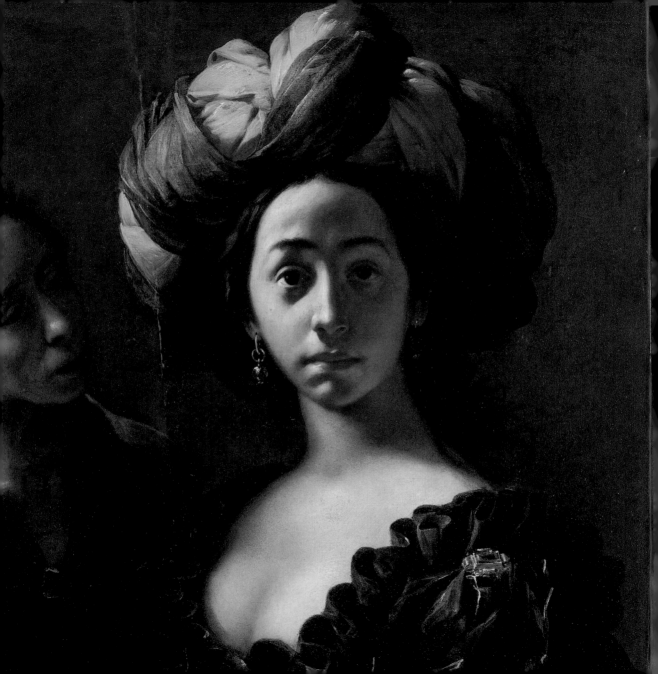

DANGEROUS WOMEN

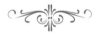

Mary D. Garrard
and Kimberly L. Dennis

Patricia & Phillip Frost Art Museum, Florida International University
and Cornell Fine Arts Museum, Rollins College
in association with Scala Arts Publishers, Inc.
featuring selections from The John and Mable Ringling Museum of Art

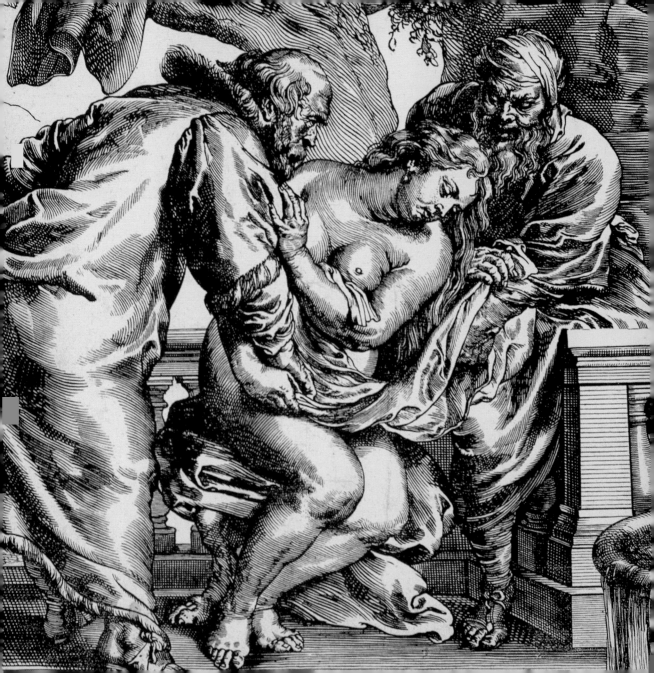

Contents

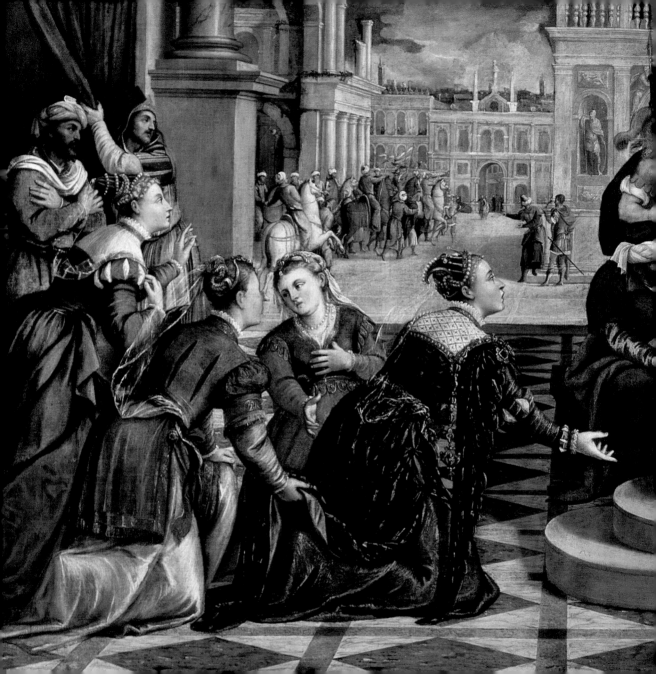

CORRVIT HESTER
CVM VIDIT
REGEM IN
SOLIO
MAIESTATIS
SVÆ

MDLXXIII

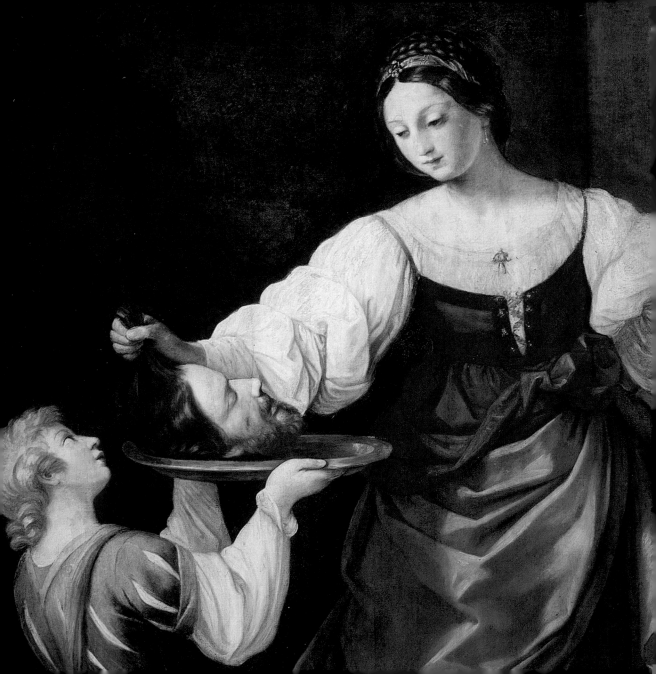

Directors' Foreword

Dangerous Women is the result of an unusual collaboration between three academic museums in Florida. As colleagues, we celebrate this unique opportunity to work together to bring a fascinating exhibition to a wide Florida audience and to rejoice in the arts of the Italian Renaissance and Baroque that reside in our state. Drawn from the collection of The John and Mable Ringling Museum of Art (the State Art Museum of Florida and a division of Florida State University), and curated by Virginia Brilliant, now Curator-in-Charge of European Paintings at the Fine Arts Museums of San Francisco, Dangerous Women is presented in spring of 2018 at The Patricia & Phillip Frost Art Museum, Florida International University in Miami, and in the fall at the Cornell Fine Arts Museum, Rollins College in Winter Park.

As teaching museums, we strive to offer our students and visitors diverse points of entry into the world of art and to balance explorations of the art of today with those of other times and places. The Ringling's rich collection of Renaissance and Baroque art will complement our own and expand the conversation. We are thrilled that our students

and visitors will have the opportunity to experience these master-pieces and to contemplate and reinterpret their meaning within our contemporary culture.

Ena Heller, Bruce A. Beal Director,
Cornell Fine Arts Museum, Rollins College

Steven High, Executive Director, The
John and Mable Ringling Museum of Art

Jordana Pomeroy, Director,
Patricia & Phillip Frost Art Museum,
Florida International University

Acknowledgments

For more than three decades, since Mary D. Garrard and other feminist art historians began questioning the litany, art history as a discipline has embraced diverse perspectives. Feminism and gender now serve as a lens to examine critically what were considered accepted truths. The histories and oeuvres of artists have been untangled, reassessed, and pieced together with new discoveries, ideas, and concepts reflective of the twenty-first century. The idea for *Dangerous Women* sprang from a simple idea of borrowing a few Old Master works from the John and Mable Ringling Museum of Art's sublime collection to exhibit in Greater Miami. Dr. Virginia Brilliant, who was the Ulla R. Searing Curator of Collections, proposed an exhibition based around women who loom large in biblical and mythological history. The theme still felt fresh and relevant: women in power can elicit a wide range of reactions from fear to admiration.

Feminist perspectives on power vary greatly but have been primarily interpreted in the context of social interaction between men and women. In *Dangerous Women* narratives of power are constructed, interpreted, and continue to evolve over the course of time. The Old and

New Testaments are full of compelling female characters—good and bad wives, courageous heroines, and deceptive—and sometimes even deadly—femmes fatales. While some women saved their people, were paragons of virtue, or repented to pursue lives of morality and sacrifice, others were purveyors of sin, harlots or hussies, or temptresses and seductresses. Even if it was through their misbehavior, all of these women—from Judith and Esther to Salome and Mary Magdalene to Delilah, Lot's Daughters, and Potiphar's Wife—shaped biblical history. *Dangerous Women* and its accompanying catalogue present twenty-three works from the rich holdings of the John and Mable Ringling Museum of Art that explore different artists' responses to the women of the Bible. Paintings by artists such as Pietro da Cortona, Francesco del Cairo, and Fede Galizia are complemented by Old Master prints and drawings, including Jan Saenredam's series entitled *Sinners of the New Testament*, and the exhibition concludes with Robert Henri's sumptuous, sensuous *Salome* from 1901, a tenacious reminder that dangerous biblical women continued to loom large in the modern imagination.

To bring *Dangerous Women* to fruition at the Patricia & Phillip Frost Art Museum, we are grateful for a grant from the Funding Arts Network of Miami-Dade County. The museum's Leadership Advisory Board as well as other members provide funding support enabling us to develop the highest caliber of exhibition programming. We thank the Ringling's Executive Director Steven High and former Curator

Virginia Brilliant for lending their museum's treasures to sister academic museums in Florida, whose missions share the goal of providing transformative experiences through art.

Jordana Pomeroy
Director
Patricia & Phillip Frost Art Museum,
Florida International University

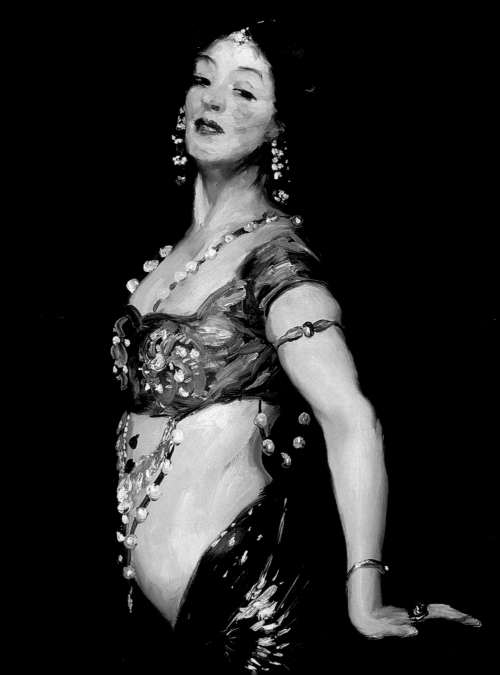

Why Are These Women Dangerous?

Mary D. Garrard

Beginning in 1925, John Ringling developed a collection of European art of the Renaissance and Baroque periods for his new palatial museum in Sarasota, Florida. Such art was largely new to local Floridians, as it was in most parts of this country outside cities like Boston, New York, or Chicago. Ringling built his collection with the advice of the German art dealer Julius Böhler, but he also relied on his own educated taste and, with his wife Mable, he was frequenting auction houses long before he built the Ringling Museum. He pioneered the collection of Baroque art in this country—large pictures with mythological and religious themes, and an unusual frequency of nude figures. Ringling went beyond the habits of rival collectors in his willingness to acquire the "sexy" examples, in a land where a puritan aversion to nudity still lingered.[1] Interestingly, many of the paintings he collected favored female protagonists, some nude and some not.

A selection of the Ringling Museum's female-centered paintings have been gathered in an exhibition called *Dangerous Women*, which focuses our attention on the dangerously seductive powers of heroines like Salome and Judith. It is a title that echoes nicely John Ringling's more famous project, the Ringling Bros. and Barnum and Bailey Circus,

which brought dangerous wild animals to frighten and thrill countless spectators around the country. There is a parallel between Ringling's two projects of collecting art and circus performers, as he himself noted when he commented on the aesthetic vitality he found in female gymnasts, galloping horses, and art.[2] Yet his enthusiasm for indulging in "a little sport" as he hunted down pictures[3] suggests another parallel. Like other major art collectors of his time—Henry Clay Frick, J. P. Morgan, William Randolph Hearst, Henry Walters—Ringling collected art competitively, amassing trophies to express a virile taste for conquest. In collecting wild beasts for his circus as well as beautiful pictures for his museum, he was able to display samples of both nature and culture. And, given the long cultural conflation of woman and nature, it is not a stretch of the imagination to compare a painting of a female temptress with a tiger in a cage—both of them sleek, beautiful, and dangerous.

All art is dangerous, in the sense that it has the power to awaken dormant ideas and beliefs, as the caged tiger can awaken primitive fears. Seductive women are potentially dangerous to men because they invoke the fear of women's power over them, threatening to disrupt cultural gender norms by turning the male into a submissive captive, while giving the female the power of agency. Hence images of Cleopatra, Judith, and Salome in art provide cautionary tales for men, presenting dangers they should avoid.

Yet art also provides an opportunity to correct the power imbalance, for artists can turn a dangerous woman back into a passive or sexually

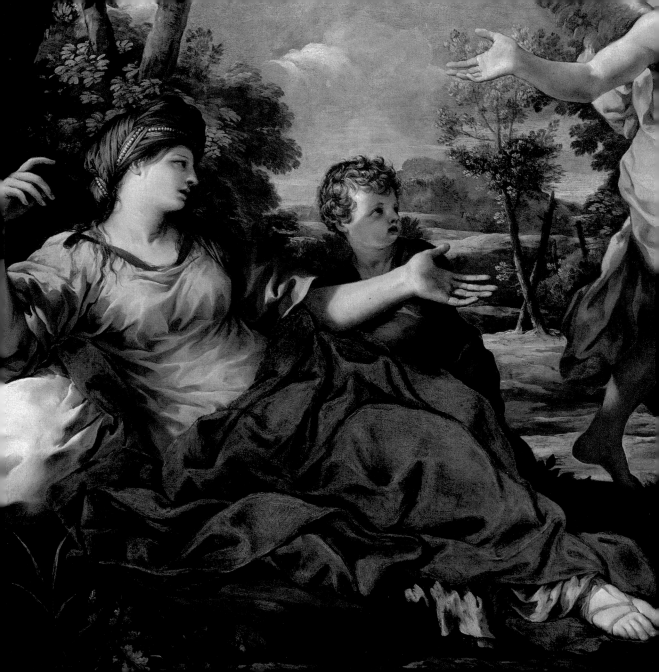

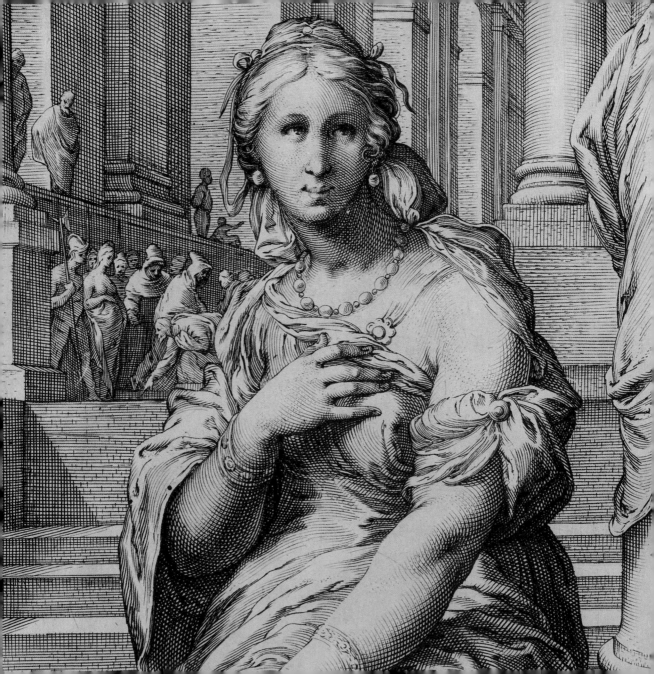

objectified being. To give just one example, the biblical Mary Magdalene, a repentant sexual sinner who was the most prominent of Christ's followers, was known in the early Christian church as a figure of active ministry and, as newly discovered Gnostic texts suggest, she was Christ's threateningly favored disciple.[4] The Magdalene's subversive power is indicated by Saint Teresa of Avila's identification with her to support Teresa's own controversially activist mission in seventeenth-century Spain.[5]

By Saint Teresa's time, however, at the height of the Counter-Reformation, Mary Magdalene had come to symbolize the sacrament of Penance, a theologically orthodox identity that emphasized her passive and submissive nature. Her original spiritual and social activism was erased. With the help of art, the Magdalene's sexually tainted past was also invoked (to link her with Eve, the original sexual sinner), and she was frequently eroticized, depicted with long, luxuriously flowing hair and titillatingly exposed breasts. These two dimensions of her fabricated identity, as both saint and sinner, doubly disempowered the Magdalene: as a saintly penitent, she was safely chaste, while the sexual appeal of a morally controlled seductress could safely be enjoyed. In the exhibition, these two aspects of her identity are represented in the *Magdalene*s based on models by Guercino and Goltzius (pp. 36 and 68).

In visual imagery, both passively chaste and suggestively eroticized women are linked through their beauty. The idea that "bad" women conceal their evil intentions behind a beautiful face and body is embedded in images that hint at a temptress behind the deceptive façade: Vincenzo

Damini's *Judith*, Sisto Badalocchio's *Susannah*, Robert Henri's *Salome*, Jan Saenredam's *Adulteress* (pp. 56, 48, 64, and 72). Yet by what definition are these women bad? Judith tricked Holofernes with seductive wiles, but with the larger and heroic purpose of saving the Jewish people. Susannah was a model wife whose only crime was bathing nude in private, which tempted the lecherous old men who spied on her. Salome was a young girl who, merely by dancing, got caught up in the intrigues of her vindictive mother and a lustful king. Christ himself pardoned the Adulteress, and urged us not to cast the first stone. The magical power of art is such that we almost forget that these women were guiltless, admirable, or heroic in their origins because they have become stamped as sexual temptresses, warped to fit the psychological and social needs of the men who have primarily shaped cultural traditions.

Women too have participated in this cultural reshaping of female identities, emulating the good-girl role models, shuddering at the evil temptresses, and accepting the saint-or-sinner myths that abound in legend and art. Yet, fortunately, there are exceptions within cultural production, which complicate and vitalize art history. Some artists, especially women, such as Fede Galizia (p. 52), empower the helpless heroines, equipping them visually with heroic strength, or giving them a quirky individuality, as in Francesco Cairo's *Judith* (p. 54).

In the Ringling exhibition, all of these images of women—idealized, eroticized and exceptional—hang side by side. Their continuing existence, like that of their counterparts in other museums, also exerts a dangerous

power. For once an image is created, it holds interpretative potential beyond the moral message that may have been intended: viewers can alter a character's identity simply by offering diverse interpretations of images that represent her; societies can change a character's meaning entirely to suit new cultural purposes. Whatever idea of Mary Magdalene an image might conjure up for a viewer, and however much it might falsify her story, that character's reality in our minds, and in history, is affirmed and enlarged by the collective power of images and their interpretation.

In recent decades, growing historical scholarship on women and gender is enabling us to evaluate the functions and social shaping of images of women in particular cultures, and to track their changing uses over time. Meanwhile, the dangerous female characters live on, both inside and outside their representations.

NOTES

1. Eric M. Zafran, "A Collection of Baroque Masterpieces," in *John Ringling: Dreamer, Builder, Collector: Legacy of the Circus King*, ed. by Mark Ormond (Sarasota, FL: The John & Mable Ringling Museum of Art, 1996), p. 73, and p. 76 for the term "sexy" used by the art historian Wilhelm von Bode to praise Ringling's acquisitions.
2. From an interview of 1928, quoted in *John Ringling: Dreamer, Builder, Collector*, p. 31.
3. Ringling's phrase in a telegram to Böhler, quoted in *John Ringling: Dreamer, Builder, Collector*, p. 76, n. 12.
4. See, for example, Karen L. King, *The Gospel of Mary of Magdala: Jesus and the First Woman Apostle* (Salem OR: Polebridge Press, 2003).
5. See Carole Slade, *St. Teresa of Avila: Author of a Heroic Life* (Berkeley and Los Angeles: University of California Press, 1995), ch. 5.

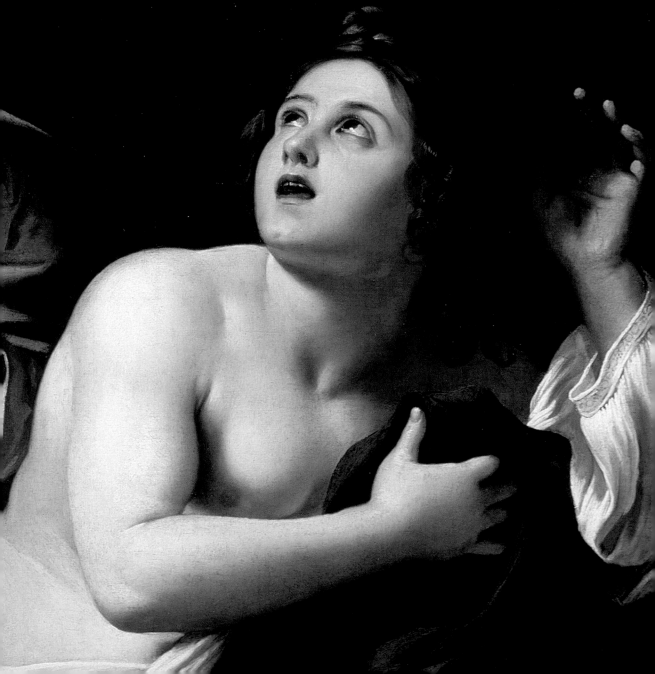

The Danger of Biblical Women

Kimberly L. Dennis

From earliest antiquity, woman was associated with a paradoxical fusion of sexual appeal and danger. After Prometheus stole fire from the gods, Zeus declared, "To them I shall give in exchange for fire an evil in which they may all take pleasure in their spirit, embracing their own evil," and out of his wrath he created the first woman, Pandora, sent to embody men's punishment. Similarly, in the Judeo-Christian tradition, God's anger unleashed evil onto the newly formed earth when Adam accepted the fruit Eve offered from the Tree of Knowledge. In the Genesis narrative, God punishes Adam, saying "Cursed be the ground because of you," while admonishing Eve, "You will desire your husband, but he will be your master." The ancient hierarchy of the genders and the notion of woman's identity as anchored in her sexuality was echoed centuries later by Aristotle, who described women as more emotional and deceptive than men. Early modern depictions of biblical heroines and female villains simultaneously reflect and perpetuate these ancient tropes, revealing the internal conflict between the danger of woman and her potential for redemption promised in the Bible. Two works from this exhibition illustrate beliefs about different forms of women's threatening sexuality and offer insight into understanding other depictions of "dangerous" women.

The Old Testament story of Bathsheba was frequently depicted by early modern artists. Lured by the beauty of his advisor's wife, King David summoned Bathsheba and "had relations with her," an encounter Bathsheba was not empowered to refuse. When she later sent word that she was "with child," David sought to conceal his sin of raping another man's wife. He arranged for Bathsheba's husband to be killed in battle and then married her when her period of mourning was complete. But "what David had done was wrong in the eyes of the Lord" and their son died soon after birth, the first of several punishments David subsequently endured. Although the biblical narrative clearly establishes David's culpability, Bathsheba is remembered as a seductress and typically blamed for her own rape and the tragedies that ensued.

In Domenico Gargiulo and Bernardo Cavallino's *Bathsheba at Her Bath* (1650s, p. 38), the artists emphasize Bathsheba's beauty as the catalyst for the story, focusing on her appeal to the male viewer rather than the punishments brought on by David's actions. Bathsheba's lustrous white body forms the focal point of the composition. Gargiulo and Cavallino depict Bathsheba at her most alluring, her nudity fully displayed for the pleasure of the (male) viewer, her body caught between the viewer's gaze and that of King David, signaling his desire for Bathsheba from his palace balcony in the background. By emphasizing her beauty and vanity, the artists implicate Bathsheba as the cause of her own violation. Set against the backdrop of maids who bathe her, arrange her hair, offer her jewelry, and proffer a mirror—a traditional symbol of vanity—Bathsheba's

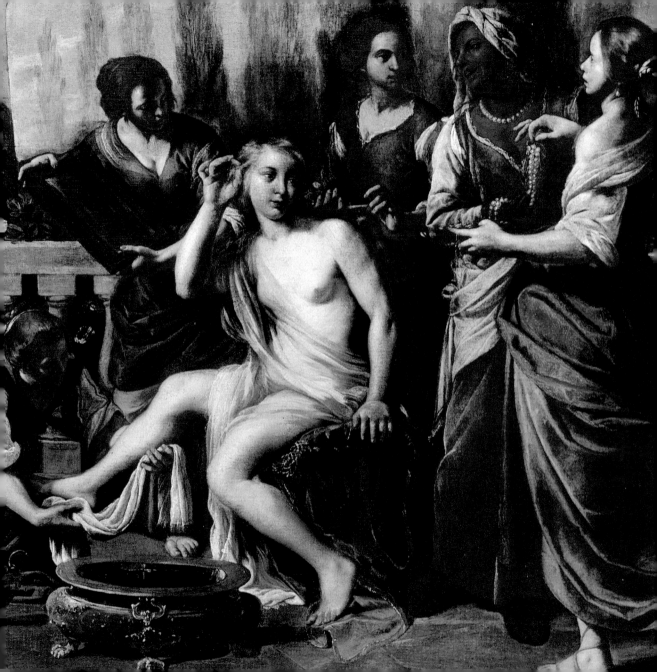

innately dangerous sexuality is countered by the white dog poised at her feet, reminding the viewer of her faithfulness to her husband, and by extension, to her God. The Three Graces carved onto the balustrade, signifying Bathsheba's youth/beauty, mirth, and elegance, also counter the seductive implications of her nude form and foreshadow her ultimate redemption. Embodying concupiscence, humanity's most fundamental sin, Bathsheba's physical attractiveness enticed a mighty king to suffer the wrath of God, yet she preserved her own virtue through steadfast faith and loyalty to her husband. Her divine reward came in the form of her second son with David, the future King Solomon, making her a heroine as the mother of a wise and just king. Like Eve, Bathsheba led a great man into tragedy and punishment, and like the Virgin Mary, her redemption and that of her people came through her son.

Following on the teachings of mythology, the Bible, and ancient philosophy, medieval theologians employed the anagram AVE/EVA as shorthand for woman's dual nature. As interpreted in an eleventh-century poem, the anagram was explained: "That angel who greets you with 'Ave'/Reverses sinful Eva's name./Lead us back, O holy Virgin,/ Whence the falling sinner came." The twelfth-century poet Wace articulated that the anagram was intended, "To allow us all to recall/ From what high point Eve made us fall."[1] As Marina Warner has aptly noted, images of Mary Magdalene proliferated in the medieval and early modern eras because her story speaks so evocatively of woman's virtue/ vice dichotomy in the Judeo-Christian tradition.[2] "Known" by Christians

as a prostitute who converted to follow Christ, Mary of Magdala is never actually identified as a prostitute in the Bible, nor is her identity clearly established in the gospel accounts, which mention a number of women named Mary. The enduring fascination with the figure of Mary Magdalene and efforts to establish the nature of her sin reflect "the powerful undertow of misogyny in Christianity, which associates women with the dangers and degradation of the flesh."[3]

The workshop copy of Guercino's lost *Penitent Magdalene* (later 1600s; p. 36) in this exhibition engages fully with the paradoxical nature of the Magdalene's role in Christianity. The viewer's gaze is first drawn to her bared right breast, framed by cascading locks of red hair, both of which signal her identity as a fallen woman. Only upon further scrutiny do we notice the single tear on her cheek and her somber gaze toward the crown of thorns she holds in her right hand while her left elbow rests on a Bible. These attributes combine references to several episodes in Mary Magdalene's story, blending the biblical with the apocryphal. The crown of thorns and Bible reference Voragine's account of the Magdalene's life after the death of Christ. According to Voragine, having preached in Provence for several years, Mary Magdalene retired to the wilderness, where she "lived unknown for thirty years in a place made ready by the hands of angels."[4] The rocky ledge on which she leans and the landscape elements in the background evoke her pious retreat, where she lived a life of solitary prayer, meditating on the suffering Christ endured for her salvation. The Magdalene's weeping attests to the sincerity of her

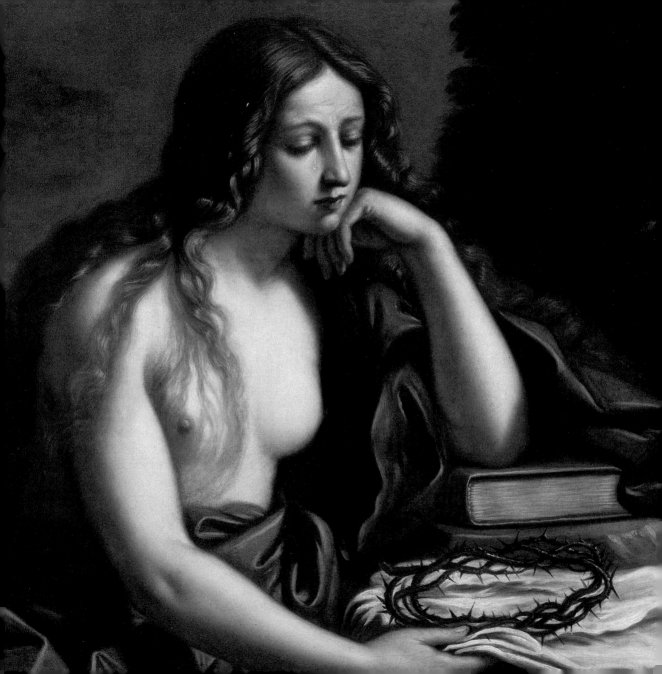

conversion, while also referencing a story recounted in Luke's gospel in which an unnamed woman, identified only as "sinful" washes Jesus' feet with her tears, dries them with her hair, and then anoints them. This and other episodes of women anointing the head or feet of Christ have long been associated with Mary Magdalene. In Matthew's gospel, the Magdalene keeps vigil at Jesus' tomb and is rewarded for her devotion as the first to see the risen Christ when he emerges.

The proliferation of images of "dangerous" women in the early modern era reflects the antiquity of a paradox that endures today: how to reconcile woman's virtuous roles as wife and mother with the fear of female sexuality. Sometimes deliberately and sometimes unwittingly, the women depicted in this exhibition lure even the most pious of men into sinful acts and disastrous consequences. Particularly when studied in the context of historical understandings of women's nature, these works can help to nuance our understanding of the history of women throughout the Judeo-Christian tradition.

NOTES

1. Henry Kraus, "Eve and Mary: Conflicting Images of Medieval Women," in *Feminism and Art History: Questioning the Litany*, eds. Norma Broude and Mary D. Garrard (New York: Harper & Row, 1982), 84.
2. Marina Warner, *Alone of All Her Sex: The Myth and the Cult of the Virgin Mary* (New York: Alfred A. Knopf, 1976), 235.
3. Ibid., 225.
4. Jacobus de Voragine, *The Golden Legend: Readings on the Saints*, trans. William Granger Ryan (Princeton, NJ: Princeton University Press, 1993), volume I, 380.

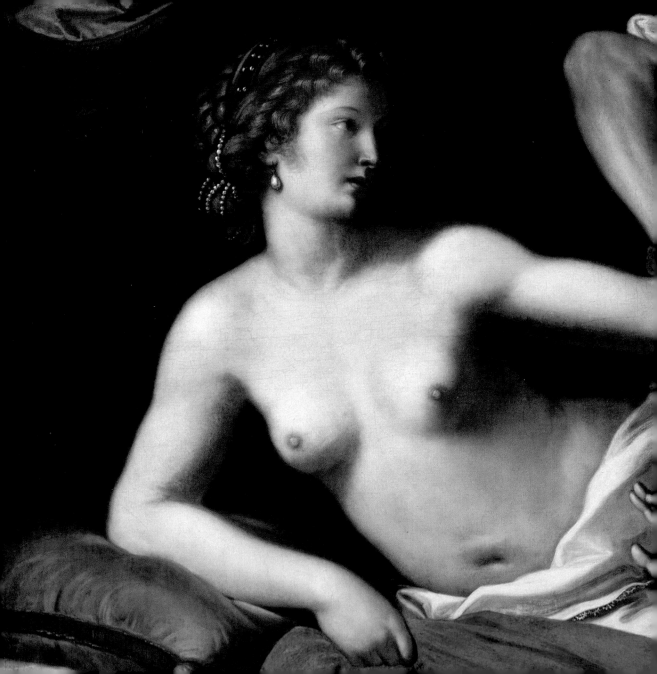

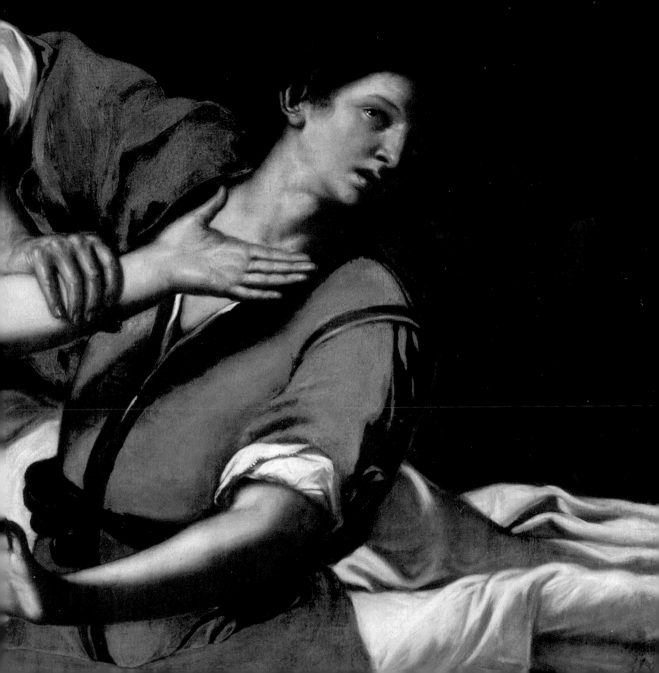

ESTHER

Antonio Negretti (ANTONIO PALMA) (Italian, Serina, near Bergamo, 1515 (?)–after 1574 Venice). *Esther before Ahasuerus*, 1574. Oil on canvas, 170.2 × 312.4 cm. Bequest of John Ringling, 1936, SN 85

The Book of Esther in the Old Testament recounts the story of Esther, chosen by Ahasuerus, king of Persia, to be his wife, unaware that she was Jewish. Shortly after, the king's chief minister, Haman, decreed that all Jews living in Persia should be killed. Esther pleaded with the king to repeal the decree. To appear before the king without being summoned was punishable by death, and Esther is therefore a symbol of great courage in the face of overwhelming danger. Ahasuerus not only pardoned Esther and overturned the decree, but ordered Haman to be hanged. In this painting, Esther entreats the King to save her people, and he holds out his golden scepter, a sign that she may speak.

The painting may commemorate the visit in 1574 of the French king Henri III to Venice, during which the Venetians solicited his help in their war with Spain. Thus, in the painting, Venice (Esther), petitions Henri (Ahasuerus), to assist her people in overcoming their enemy Spain (Haman). Esther's headpiece is a small version of the *corno* worn by Venice's doge, closer in size to the *cornetto* worn by the dogaressa; Ahasuerus' crown and scepter are adorned with the fleurs-de-lis of the French royal arms, while his features seem to be an idealized version of Henri III's. The scene is set in Venice's famous Piazza San Marco.

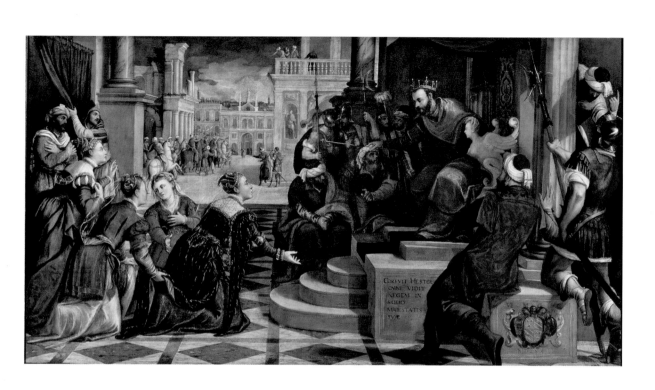

POTIPHAR'S WIFE

Workshop of GUERCINO (Giovanni Francesco Barbieri) (Italian, Cento 1591–1666 Bologna). Copy after Guercino's *Joseph and Potiphar's Wife*, ca. 1648–50. Oil on canvas, 134.3 × 167.6 cm. Bequest of John Ringling, 1936, SN 124

This painting (a workshop copy of Guercino's original in the National Gallery of Art, Washington) depicts a story from the Book of Genesis in the Old Testament, which tells how Joseph was bought by Potiphar, the Egyptian captain of Pharaoh's guard, and appointed overseer of his household. Potiphar's wife attempted to seduce Joseph several times, but he rejected her advances. One day, "she caught him by his garment, saying, 'Lie with me.' But he left his garment in her hands, and fled . . . " Later, using the garment as evidence, she denounced Joseph as the seducer.

Guercino's composition depicts the struggle over the garment. The life-sized figures press close to the viewer, and Potiphar's wife, entwined in rumpled sheets, reclines on a bed secluded by opulent curtains. With imperiousness and serenity, the temptress reaches for Joseph's neck with one hand, and grasps his blue cloak with the other. A look of panic crosses Joseph's face as he struggles to extricate himself, as it dawns on him that if he escapes with his virtue unscathed, he is still helplessly ensnared in an evil plot. Just as this woman's beauty conceals her wickedness, so the visual lushness of Guercino's painting disguises a serious lesson about righteous conduct.

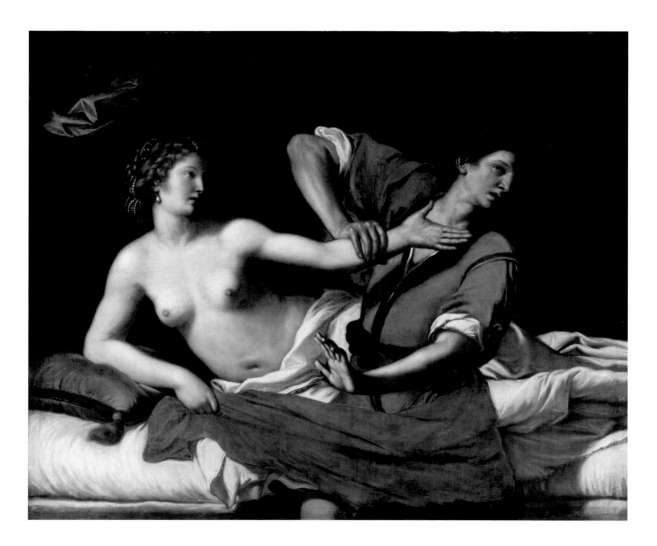

MARY MAGDALENE

Circle of GUERCINO (Giovanni Francesco Barbieri) (Italian, Cento 1591–1666 Bologna). Copy after Guercino's lost *Penitent Magdalene*, later 1600s. Oil on canvas, 119.4 × 96.5 cm. Bequest of John Ringling, 1936, SN 126

A sinner, perhaps a courtesan, Mary Magdalene was a follower of Christ who renounced the pleasures of the flesh for a life of penance and prayer. According to *The Golden Legend*, after Christ's death, she took refuge in a grotto near Marseilles, where she was visited daily by angels, who gave her divine sustenance through their songs. In the seventeenth century particular emphasis was placed on Mary Magdalene's conversion and penitence. As she was thought to be a converted prostitute, Baroque artists typically showed her as at once extraordinarily beautiful and deeply penitent in images that combined sensuality with profound feeling. In the present painting, she is shown contemplating Christ's crown of thorns—and thus his Passion—while resting her elbow on a book, ostensibly a volume of devotional literature. The painting is a version of a lost original by Guercino.

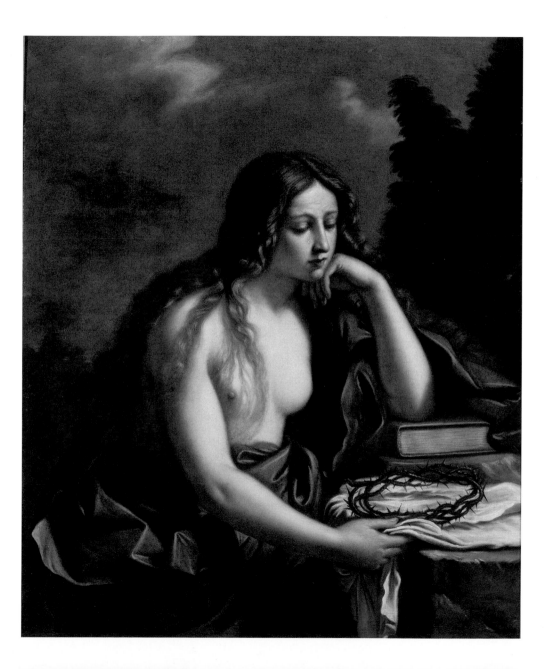

BATHSHEBA

Followers of DOMENICO GARGIULO ("Micco Spadaro") (Italian, Naples 1609/10–1675 Naples (?)) and BERNARDO CAVALLINO (Italian, Naples 1616–1656 Naples) active in the workshop of ARTEMISIA GENTILESCHI (Italian, Rome 1593–1651/53 Naples). *Bathsheba at her Bath*, 1650s. Oil on canvas, 84.5 × 115.6 cm. Gift of Asbjørn R. Lunde, 1976, SN 955

The story of David and Bathsheba can be found in the Old Testament (2 Samuel 11–12). King David spied Bathsheba, the wife of the Hittite soldier Uriah, who was away at war, while she was bathing in her garden. David was immediately taken with her beauty and seduced her, after which she conceived a child. Following several unsuccessful attempts to reconcile the cuckolded Uriah with his unfaithful wife, David finally ordered him into battle, and placed him "in the forefront . . . that he may be smitten, and die." Uriah was killed, and David married Bathsheba. David was, however, punished for his behavior: his child by Bathsheba died. At upper left, David leans over the balcony of his palace, gazing towards his future wife. She is pampered by maidservants who dry her naked limbs and offer her trays of jewelry and a mirror—props signifying her vanity. Beside the golden washbasin and water jug at her feet is a small white lapdog, traditionally a symbol of fidelity, but here more likely to offer a parallel to the pampered Bathsheba, whose indulgences will lead to treachery.

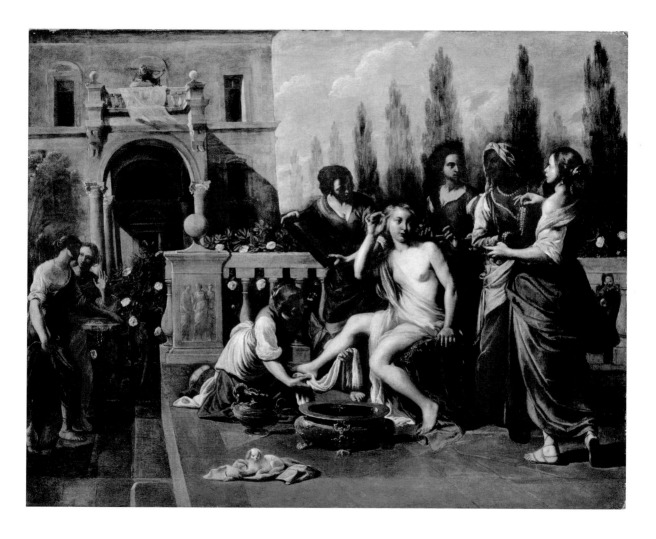

LUCRETIA

Attributed to EMILIO SAVONANZI (Italian, Bologna 1580–ca. 1660 Camerino). *Suicide of Lucretia*, ca. late 1620s. Oil on copper, 17.9 × 12 cm. Gift of Mr. and Mrs. Richard A. A. Martin, 1961, SN 728

The tragic story of Lucretia, recounted by Livy and Ovid, took place in Rome in the 6th century BC during the tyrannical reign of Tarquinius Superbus. Lucretia's husband, Collatinus, boasted to his fellow soldiers that his wife's loyalty and virtue were greater than that of their own. Intrigued, the men rode to Rome where they discovered the lovely Lucretia and her handmaidens spinning wool. Yet Lucretia's virtue enflamed the desire of Sextus Tarquinius, son of Tarquinius Superbus, and a few days later he secretly returned to Collatinus' house and threatened to kill Lucretia if she did not yield to him. The next day Lucretia summoned her father and husband to disclose what had happened. Although they deemed her an innocent victim, she was determined to end her life in order to reclaim her honor, and proceeded to drive a knife into her heart. Overwhelmed by grief and anger, Lucretia's father and husband swore to avenge her death, and thus her rape and suicide triggered a revolt that led to the overthrow of Tarquinius Superbus and the subsequent creation of the Roman Republic. This small painting on copper shows the moment before Lucretia inflicts the fatal wound, dagger in hand, standing in the bedchamber where she was shamed.

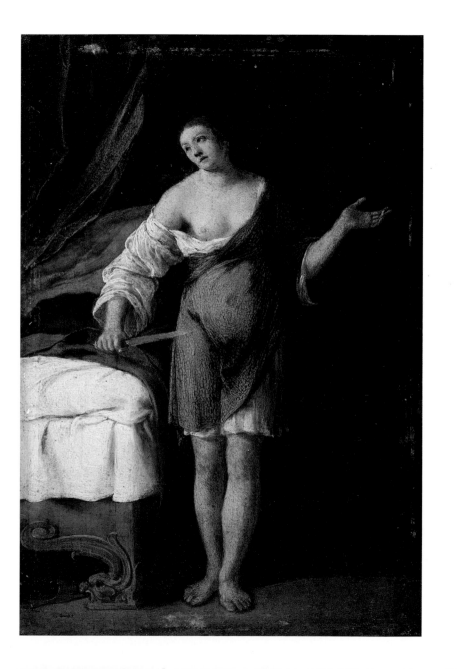

LUCRETIA

Jacopo Palma the Younger (PALMA IL GIOVANE) (Italian, Venice ca. 1548–1628 Venice). *Rape of Lucretia*, before 1595. Pen and brown ink with brush and brown wash, heightened with white gouache, framing lines in black ink, 27.9 × 22.9 cm. Museum purchase 1971, SN 898

In this drawing, the Venetian artist Palma Giovane chose to depict not Lucretia's suicide (see p. 40), but rather her rape. Lucretia is shown nude as she attempts, in vain, to fend off Tarquinius, who holds her down with one hand and raises his sword—which lends itself to a sexual interpretation—with the other. The drawing seems to be a study for two paintings ascribed to Palma Giovane now in the Gemäldegalerie Alte Meister, Kassel, and the State Hermitage Museum, Saint Petersburg. Yet both of these paintings are horizontal in format, in contrast with the vertically oriented drawing. Thus, the drawing likely represents an early stage in the artist's thinking about the subject, and is clearly indebted to Titian's interpretation of the subject, now in the Fitzwilliam Museum, Cambridge. Given, however, that Palma's figures are in reverse of Titian's, it is possible that Palma was looking not at Titian's painting, which was sent to Spain not long after it was completed in 1571, but rather at Cornelis Cort's print after the famous Titian.

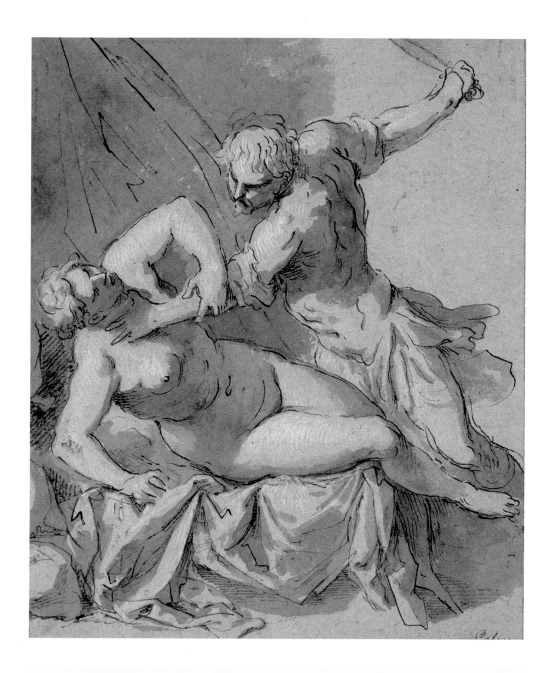

HAGAR

PIETRO DA CORTONA (Pietro Berrettini) (Cortona 1596–1669 Rome). *Hagar and the Angel*, ca. 1643. Oil on canvas, 114.3 × 149.4 cm. Bequest of John Ringling, 1936, SN 132

The subject of the painting—one of the gems of the Ringling collection—is taken from the Old Testament (Genesis 16 and 21:9–21). The patriarch Abraham had a son called Ishmael by Hagar, the Egyptian maidservant of his aged and barren wife, Sarah. When Sarah miraculously conceived and gave birth to Isaac, she demanded that Hagar and Ishmael be banished, to which Abraham reluctantly agreed. In the wilderness, mother and son lost their way and their supplies were depleted. In this moment of desperation, God heard Ishmael's cries and an angel appeared to direct Hagar to a source of water, as well as prophesying that Ishmael's heirs would found a great nation. This painting depicts Hagar and Ishmael's salvation, rather than their agony. In a cool, verdant landscape, Hagar reclines in relief on her travelling bundle as she receives the reassurances of the elegant angel. Ishmael, it might be noted looks alarmed, but such an expression is perhaps not out of keeping with having experienced a heavenly apparition, a miracle, and the announcement of his future greatness all in one day.

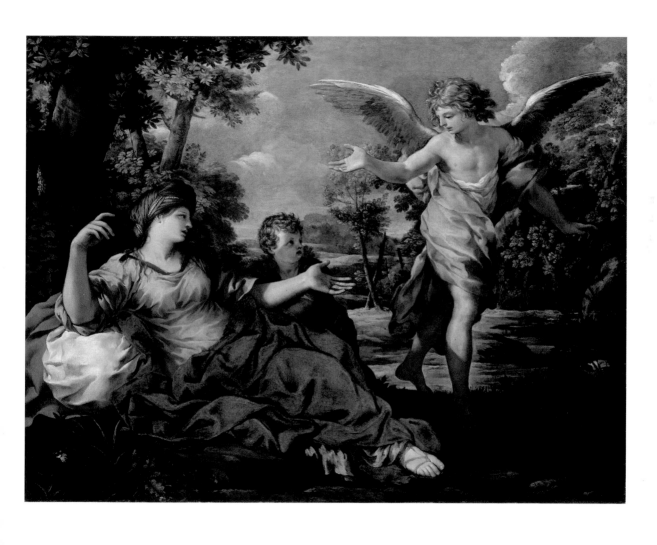

HAGAR

KAREL DUJARDIN (Dutch, Amsterdam 1622–1678 Venice). *Hagar and Ishmael in the Wilderness*, ca. 1662. Oil on canvas, 187.3 × 142.9 cm. Bequest of John Ringling, 1936, SN 270

This painting shares its subject with the one by Pietro da Cortona (p. 44). According to the Old Testament, Hagar and her son Ishmael were banished from the house of Abraham, the child's father (Genesis 16 and 21:9–21). Wandering in the desert and dying of thirst, Ishmael cried out, and God produced a well of water and an angel foretelling Ishmael's founding of a great nation. In contrast with Cortona's elegant handling of the subject, Dujardin presented the story as one of outcasts comforted and redeemed, and expressing thanks for the angelic intervention. Hagar kneels before the angel, her facial features at once revealing her desperation and her gratitude; the pitiful Ishmael, his features sallow and his ribcage visible, drinks deeply from the bowl proffered by his mother. Inspired by many sojourns in Italy, Dujardin did not embrace the harsh shadows, shades of gray, brown, and black, and human models used by his near-contemporary, Rembrandt, but instead incorporated the luminous surfaces, light colors, and idealized physical types of the classical tradition. His draperies crinkle and fold, furl and unfurl, with a calligraphic grace, at once stiff and weightless. All seems suffused with divine light, emphasizing the miraculous nature of the event.

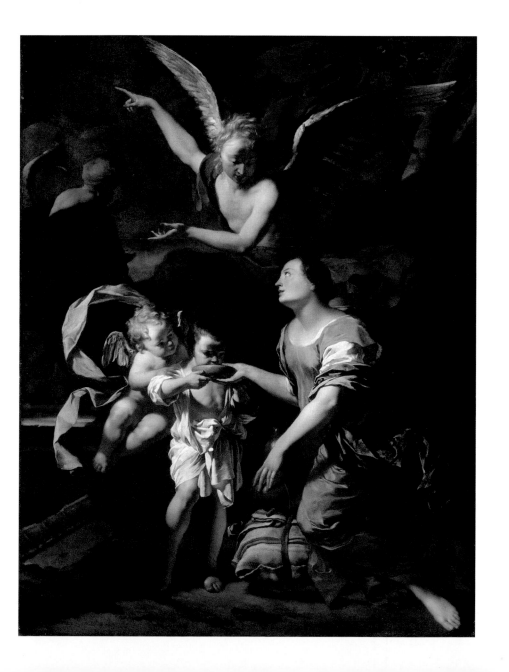

SUSANNAH

SISTO BADALOCCHIO (Parma 1585–1619 Parma). *Susannah and the Elders*, ca. 1602–10. Oil on canvas, 162.4 × 111.4 cm. Bequest of John Ringling 1936, SN 111

The story of Susannah and the Elders comes from the apocryphal Old Testament Book of Daniel (Daniel 13:15–25) and supposedly occurred in Babylon in the 6th century BC. Susannah, the beautiful wife of Joachim, walked daily in her garden, where she was spied upon by two Elders, whose lust was so great that they decided they must seduce her. One day while Susannah was bathing, they sprang upon her, saying that if she did not succumb, they would denounce her publicly. The chaste Susannah refused and was therefore tried and sentenced to death for adultery. She was only saved when the young Daniel came forward and revealed the Elders' treachery. While some images of Susannah present her as heroine symbolizing salvation and divine justice, as well as marital fidelity, in other cases her story was simply a pretext for depicting an attractive female nude subjected to, and often startled by, the attention of aged voyeurs.

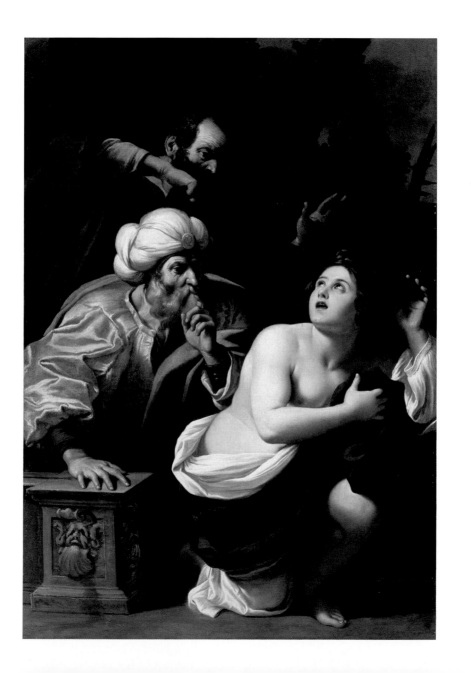

SUSANNAH

CHRISTOFFEL JEGHER (Flemish, 1596–1652/53) after Peter Paul Rubens (Flemish, Siegen 1577–1640 Antwerp). *Susannah and the Elders*, 1632–36. Woodcut, 44.1 × 57.8 cm. Museum purchase, 1982, SN 8952

Susannah (see p. 48) is seated beside a balustrade at the edge of a bathing pool, at the center of which is a fountain crowned with a dolphin ridden by a putto. The lascivious Elders approach her, one from each side, attempting to remove the cloth covering her body. The Elder at right, with a primitive, satyr-like visage, moves impetuously to grasp Susannah's garment, while his companion, whose features are more refined, approaches Susannah more cautiously, placing his hand beside hers. Thus, the two characters are contrasted: one acts with lusty greed, going straight for his objective, while the other pursues his sensual impulses more gently. Nevertheless, their attentions are unwanted, and, hemmed in by the balustrade and the pool, Susannah has no escape. Aware of her helplessness, she slumps in limp resignation. Her head has sunk to her shoulder, and her downcast glance is rife with grief and shame at the harm befalling her. This print is based on a now-lost painting by Peter Paul Rubens. Under Rubens' supervision, the printmaker Christoffel Jegher made a woodcut reproducing the painting's composition in reverse.

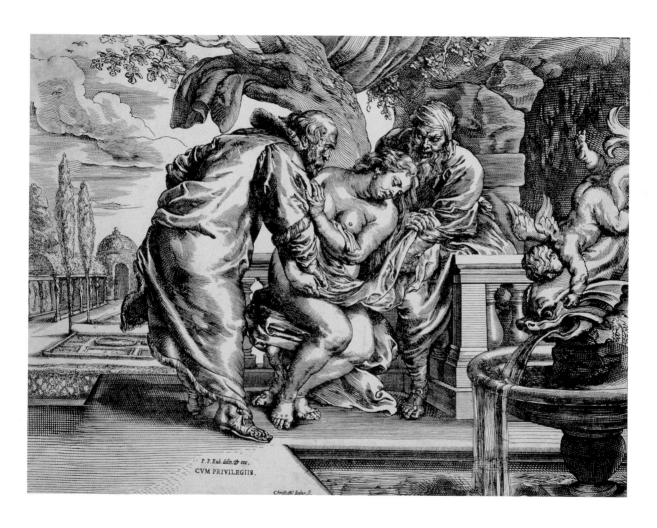

P. P. Rub. delin. & exc.
CVM PRIVILEGIIS.

Chriſtoffel Ieſber ſc.

JUDITH

FEDE GALIZIA (Italian, Milan or Trent 1578–1630 Milan). *Judith with the Head of Holofernes*, 1596. Oil on canvas, 143.3 × 118.1 cm. Gift of Mr. and Mrs. Jacob Polak, 1969, SN 684

As recorded in the Book of Judith in the Old Testament (12:10–20; 13: 1–12), the Assyrian general Holofernes intended to annihilate the Jews of Bethulia. Yet in spite of this plot, Holofernes became enamored with a beautiful Jewish widow named Judith. He invited her into his tent with the aim of seducing her, but, besotted by her beauty and inebriated with drink, he reclined on his bed, and Judith, with the help of her maidservant Abra, decapitated the general using his own sword. Judith thus courageously liberated her people. This painting is one of the very few in the Ringling's Old Master collection made by a woman artist, Fede Galizia. Galizia portrayed Judith, accompanied by Abra, against a red swag of drapery, brandishing both Holofernes' head and the blade with which she severed it—she also signed and dated the work on the blade held by the biblical heroine. Judith is sumptuously dressed and heavily bejeweled, recalling the biblical text, which states that Judith put aside her widow's weeds and adorned herself in rich clothing to inspire Holofernes' lust. The gray-blue bodice, formfitting and almost metallic, resembles an armored breastplate, alluding to the masculine, militant nature of Judith's act.

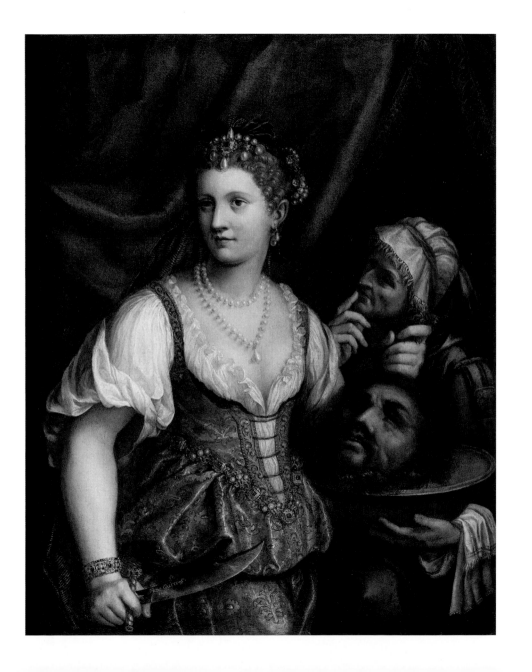

JUDITH

FRANCESCO CAIRO (Italian, Milanese, 1607–1665). *Judith with the Head of Holofernes*, ca. 1633–37. Oil on canvas, 119.1 × 94.3 cm. Museum Purchase, 1966, SN 798

Francesco Cairo is best known for his pictures showing macabre subjects, particularly tragic heroines in moments of extreme emotion. Sensuously combining the dramatic, the gruesome, and the ecstatic, these passionate pictures reveal Baroque art's sinister and erotic fascination with violence and death. *Judith with the Head of Holofernes*—depicting the Jewish widow who seduced and killed the Assyrian general Holofernes to prevent him from ravaging the city of Bethulia (see p. 52)—is one of the artist's masterpieces. Judith is dressed in a voluminous black gown punctuated with flickering white highlights. Ensconced in its folds, Judith's form almost disappears into the mysterious darkness of the tent where, in the dead of night, Judith beheaded the drunken Holofernes with his own sword. The pallor of Judith's skin against the pitch black is alluringly tactile; the splendid yellow and blue turban an exoticism heightening the sense of intrigue and seduction. While the middle finger of her otherwise soft, girlish hand is like a claw—hideous, elongated, and deformed—her right hand, firm upon the hilt of her sword, is resolute, brave, and victorious. Her maidservant, a wrinkled crone dressed in red, opens her mouth in alarm, entreating her mistress to flee. But Judith's face is impassive, transfixed by the enormity of the moment. Half is in the light, but half is in shadow, suggesting that her act of heroism was also one of horror.

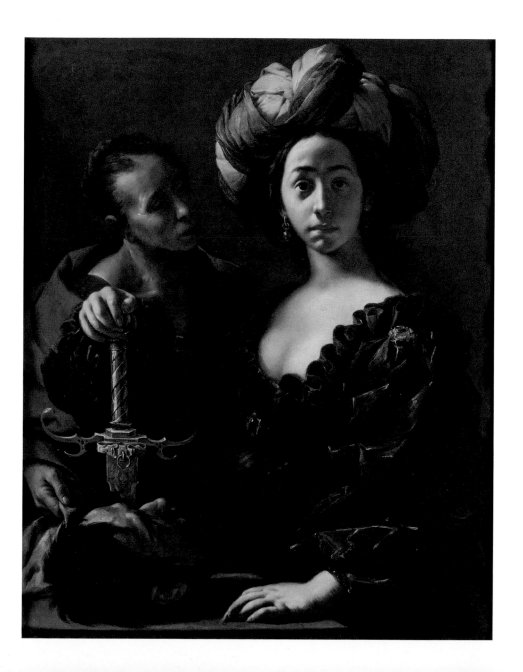

JUDITH

VINCENZO DAMINI (Italian, Venice late 1600s–1749 Aquila). *Judith with the Head of Holofernes*, late 1720s. Oil on canvas, 149.9 × 111.1 cm. Bequest of John Ringling, 1936, SN 178

The Old Testament heroine Judith saved the Israelites from the forces of Assyrian king Nebuchadnezzar by beheading his general Holofernes. According to the Book of Judith: "Judith stood beside Holofernes' bed and prayed silently: 'O Lord, God of all powers, look favorably now on what I am about to do to bring glory to Jerusalem' . . . She went to the bedrail beside Holofernes' head and took down his sword and stepping close to the bed, she grasped his hair. 'Now give me strength, O Lord, God of Israel,' she said. Then she struck at his neck twice with all her might, and cut off his head." In this painting, Judith looks heavenward, praying to God for his favor in her execution of this grisly deed; she is also in the middle of the deed itself, holding Holofernes' head as a spray of blood erupts from his neck, his body agonizingly contorted on the bed behind her. Her maidservant appears at left, ready to receive the head in a cloth. A ray of divine light enters the picture from the upper left, theatrically spotlighting Judith and confirming that her prayers have been answered.

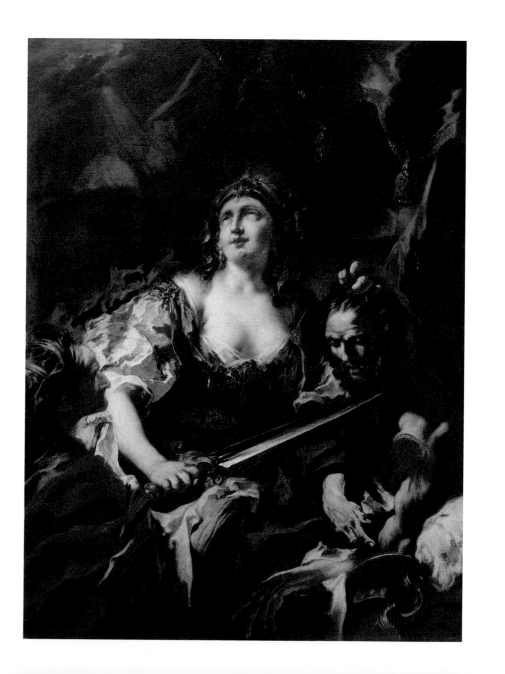

HERODIAS

PALMA VECCHIO (Jacopo Negretti) (Italian, Serina, near Bergamo, 1479/80–1528
Venice). *Herodias with the Head of John the Baptist*, ca. 1515–20. Oil on wood,
93.3 × 82.2 cm. Bequest of John Ringling 1936, SN 66

The subject of this painting derives from the New Testament (Matthew
14:1–11), which recounts how King Herod, captivated by the dancing of
his stepdaughter, Salome, offered her any reward. At the urging of her
mother, Herodias, Salome requested the head of John the Baptist, who
had criticized her mother's marriage. At the center of this painting is
Herodias, triumphantly displaying her prize on its platter, and flanked
by the executioner, at left, and the young Salome, at right. Idealized,
often eroticized, half-length portraits of beautiful young women,
characterized by their sensuality, free-flowing hair, and semi-undress,
were a staple of Venetian Renaissance painting, and were likely designed
to appeal to the romantic and erotic longings of a male owner. These
imaginary beauties, or *belle donne*, are sometimes shown with the
attributes of ancient heroines, like Lucretia, or goddesses such as Venus
or Flora; others are simply pure embodiments of the poetic ideal of the
perfect woman; still others cast these women in the guise of biblical
heroines like Judith and Herodias.

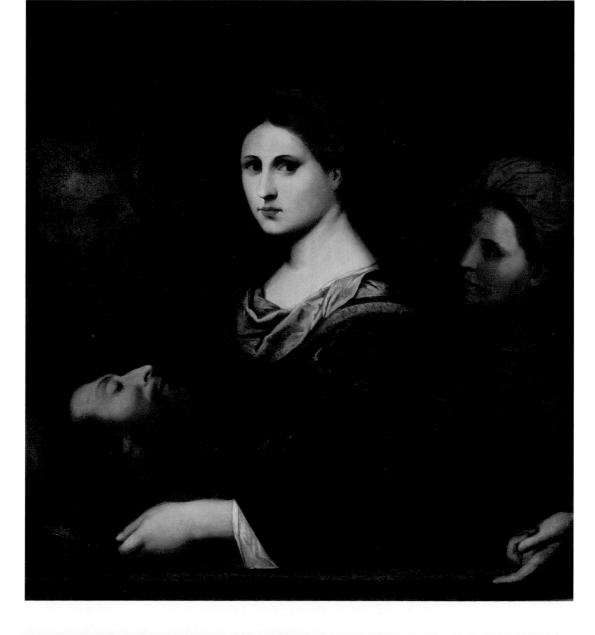

SALOME

Workshop of GUIDO RENI (Italian, Bologna 1575–1642 Bologna). *Salome Receiving the Head of John the Baptist*, ca. 1639–42. Oil on canvas, 190.5 × 152.4 cm. Bequest of John Ringling, 1936, SN 119

This large canvas is a workshop variation, and reduction, of the painting by Guido Reni now in the Art Institute of Chicago. The monumental, elegantly dressed figures enact one of the New Testament's most violent stories, the death of the prophet John the Baptist. John criticized King Herod for marrying Herodias, and as a result of Herodias' rage over the prophet's condemnation, John was thrown in prison. In the meantime, a dance presented by the beautiful Salome, Herodias' daughter, so pleased the king that he offered the girl whatever she wanted. Prompted by her vengeful mother, Salome asked for John's head. Reni depicted the moment when the Baptist's decapitated head is presented to Salome on a platter. In spite of his grisly demise, John the Baptist's expression is serene. Salome, for her part, recoils slightly from the head, but regards it with a cool, sanguine expression, while the page holding the platter crouches nervously beside her.

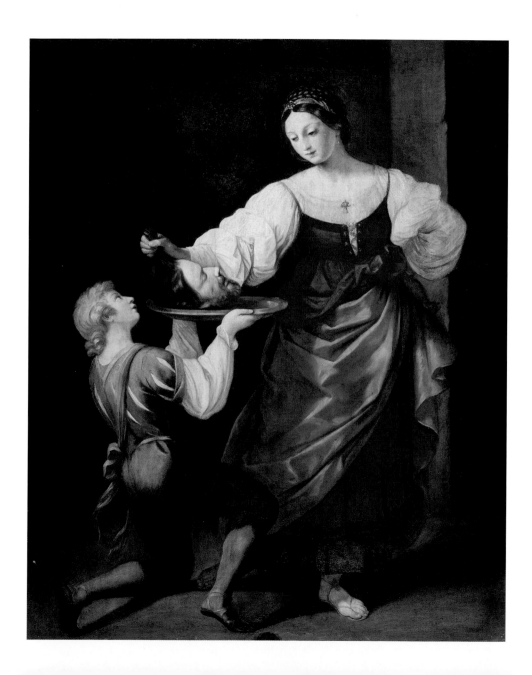

SALOME

BARTOLOMEO CORIOLANO (Italian, Bologna ca. 1599–ca. 1676 Bologna (?)) after GUIDO RENI (Italian, Bologna 1575–1642 Bologna). *Salome with the Head of John the Baptist*, 1631. Woodcut, 16.2 × 18.9 cm. Museum purchase, 1972, SN 8702

The printmaker Bartolomeo Coriolano worked almost exclusively with the renowned Bolognese painter Guido Reni, translating the artist's paintings into woodcuts. One of Coriolano's earliest efforts was *Salome with the Head of John the Baptist*, which can be linked to a painting by Reni purchased from the artist by Pope Urban VIII in 1639 and now in the Galleria Nazionale dell'Arte Antica, Palazzo Corsini, Rome. The painting, however, shows only Salome holding the platter with the head, while in the print the composition has been expanded to include a figure who may be Herodias, Salome's mother, receiving the gift she so desired. The inscription in the cartouche at the top left notes that the print was made by Coriolano after Reni.

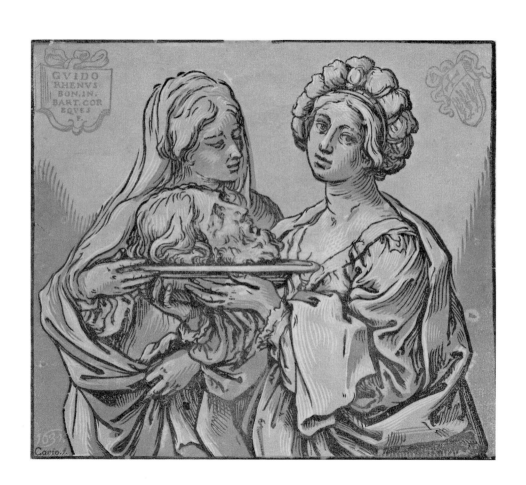

GVIDO
RHENVS
BON. IN.
BART. COR
EQVES
F.

1632

Carto.f.

SALOME

ROBERT HENRI (American, Cincinnati 1865–1929 New York). *Salome*, 1909. Oil on canvas, 196.9 × 94 cm. Museum purchase, 1974, SN 937

In 1907, all New York was so scandalized by Richard Strauss' opera *Salome*, based on Oscar Wilde's play, that its staging was suppressed after only one performance. According to the New Testament, the young Salome danced so magnificently at the birthday banquet of her stepfather, King Herod, that he promised to grant her any request. At the urging of her mother, Herodias, Salome asked for the head of John the Baptist. Strauss and Wilde transformed the already gruesome tale into something cruel and sexually charged, interpreting Salome not as an innocent young girl acting on her mother's instructions, but as a grown and dangerously sensual woman scorned by John the Baptist and ready to exact revenge using her considerable wiles. Unable to see the opera performed in New York, the painter Henri invited Mademoiselle Voclezca, who had performed the dance of Salome in Strauss' opera, to reenact the notorious Dance of the Seven Veils in his studio so that he could paint her. The temptress steps forward and arches her back. Her face is flushed; her lips are parted. Henri's sensuous brushwork suggests the alluring, undulating rhythms of the voluptuous dance.

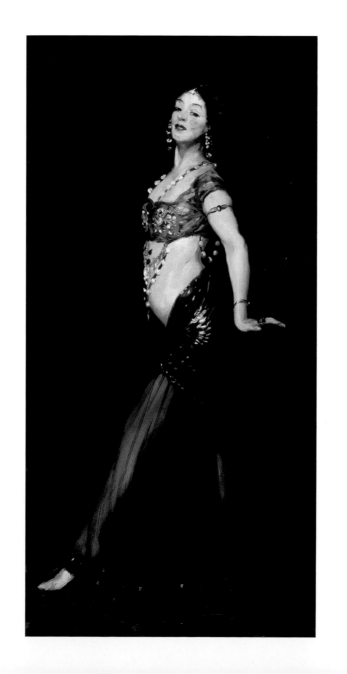

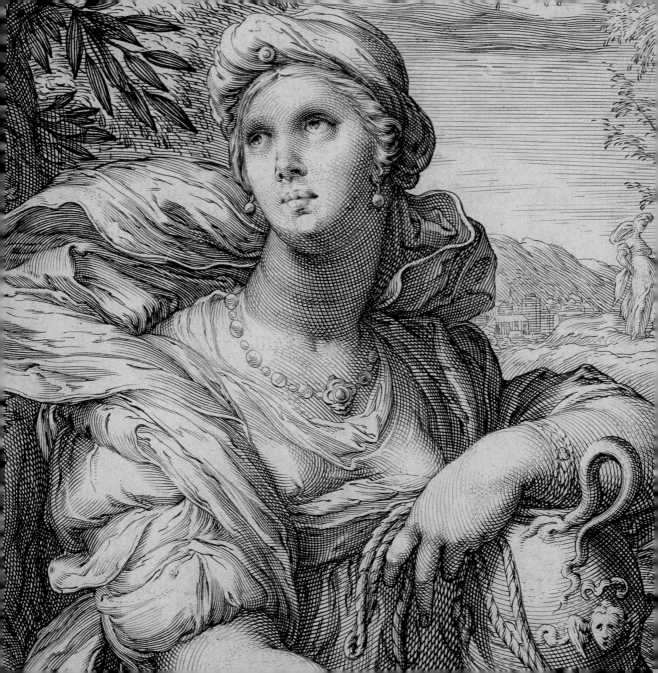

Famous Women of the New Testament

JAN SAENREDAM (Netherlandish, Zaandam ca. 1565–1607 Assendelft) after
HENDRICK GOLTZIUS (Netherlandish, Mühlbracht 1558–1617 Haarlem). *Five
Engravings from the Series of Famous Women of the New Testament*, 1600s. Engraving, each
19.1 × 13.3 cm. Museum purchase, 1973, SN 8768.1–6

Jan Saenredam began as an apprentice to Hendrick Goltzius, and later
set up his own production shop for prints after Goltzius and other
Dutch artists. Saenredam's work after Goltzius frequently included
cycles, including allegories of the *Four Seasons*, *Times of Day*, *Five Senses*,
Seven Planets, and even *Three Kinds of Marriage*. The series presented here
shows women from the New Testament, all of whom were touched by
Christ's grace.

Mary Magdalene

A sinner, perhaps a courtesan, Mary Magdalene was a companion of Christ who renounced the pleasures of the flesh for a life of penance and contemplation. Here she is shown in a manner recalling medieval descriptions of her beauty: "Mary, when she reached marriageable age, glorious in the lovely beauty of her body, exceedingly splendid, was radiant in the graceful movement of her limbs, her beautiful countenance, her marvelous hair, her most gracious demeanor, her sweetly yielding spirit; the beauty of her face and the grace of her lips were as the whiteness of lilies mixed with roses. Finally so great was the frame which shone forth from her form and beauty that she was called an unparalleled and miraculous creation of God, the artist." She has not cast off her finery. Her hair is both a marker of her sinful ways and prophetic of penitent ones: having initially exploited it as an asset in her life of sin, she later used it to dry Christ's feet in the house of Simon. She holds in her hands a vessel containing the precious oils that she used to anoint Christ's feet as she wept over them, repenting of her sins. This act is pictured in the right background.

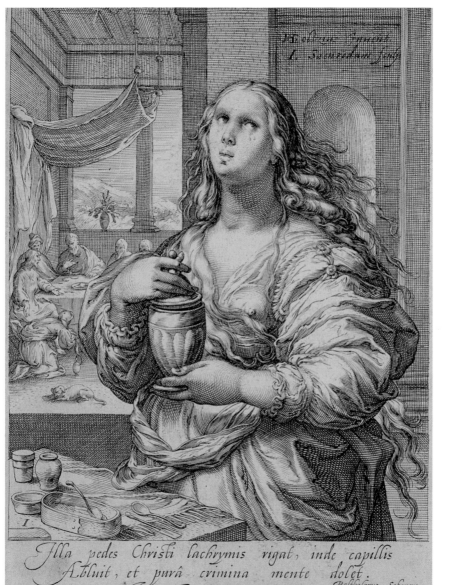

The Samaritan Woman

The story of the Samaritan woman is told in the Gospel of John (4:5–42). Jesus, traveling through Samaria, sat down to rest beside a well. A woman came to draw water, and he asked her for a drink. She expressed her surprise that a Jew would even speak to a Samaritan, to which Jesus replied: "Everyone who drinks of this water will thirst again, but whoever drinks of the water that I shall give him will never thirst." Shown here, the Samaritan woman has grasped Christ's message—that he is the living water, the source of eternal life. In the background, her encounter with Christ can be glimpsed.

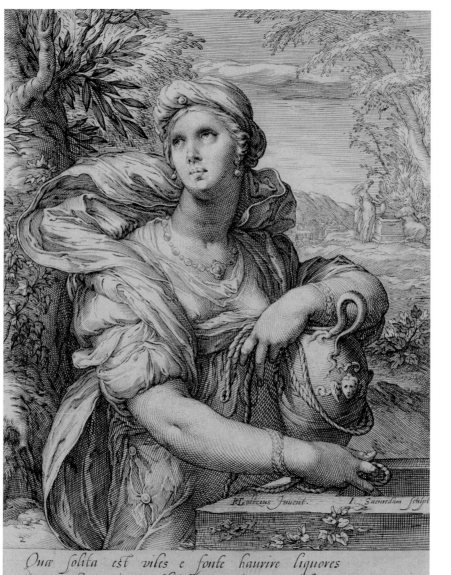

H. Goltzius Inuent. I. Saenredam sculpt.

Quæ solita est viles e fonte haurire liquores
Nunc vivas Christi numine promit aquas.
 Balthasarus. Schoneus.

The Adulteress

In the Gospel of John (8:7), a woman accused of adultery—an offense then punishable by death—was brought by the Pharisees before Christ. When he was asked if she should be stoned, Christ responded to her accusers: "He that is without sin among you, let him first cast a stone at her." This print shows the Adulteress, whose serene expression suggests she has been redeemed of her transgression through Christ's grace, while in the background, she stands nude from the waist up, surrounded by her accusers.

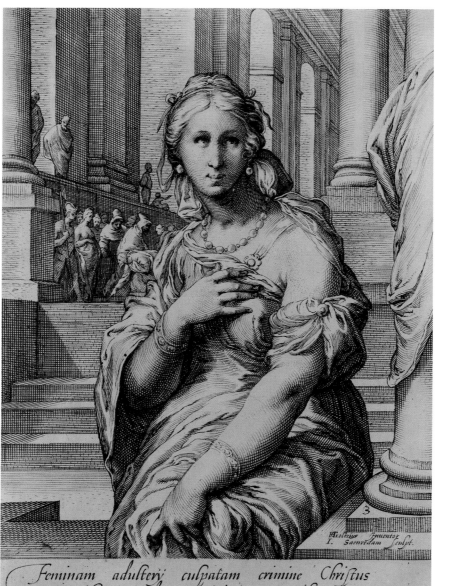

3

Ncolaus Inuentor
I. Saenredam sculpt.

Feminam adulterij culpatam crimine Christus
Scribarum diris eripit e manibus. Balthasarus. Schonpis

The Canaanite Woman

In the Gospel of Saint Matthew (15:21–28), when Christ and his disciples were on their way to Cana, they met a woman who begged Christ to heal her sick daughter. Ignoring the protests of his followers, who objected that the woman was not an Israelite, Christ performed the miracle. The Canaanite woman here clutches her hand to her breast in a gesture of thanksgiving, while in the background she kneels in the immediately previous moment in the narrative, beseeching Christ and his companions. The two small dogs in the right foreground refer to the fact that Jesus initially refused her request, saying, "It is not right to take the children's bread and toss it to the dogs," as Jews considered Gentiles "dogs" on account of their idolatry. The Canaanite woman replied, with great humility, "Even the dogs eat the scraps that fall from the table of their masters," and it was her perseverance in the face of his rejection and humiliation that earned her Christ's intervention.

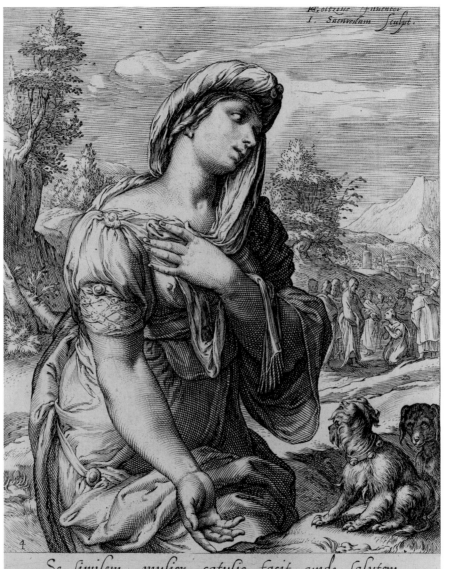

4

Se similem mulier catulis facit, vnde salutem.
Nacta, Deum laudat nocte dieq suum.

Balthasar. Schonev.

The Woman with the Issue of Blood

According to the Gospels, Jesus encountered among the crowd of people a woman who had been subject to bleeding for twelve years. The woman touched Jesus' garment and was immediately healed. As in the other works in the series, the woman is featured in the foreground of the engraving, while the moment in which she meets Christ figures in the background.

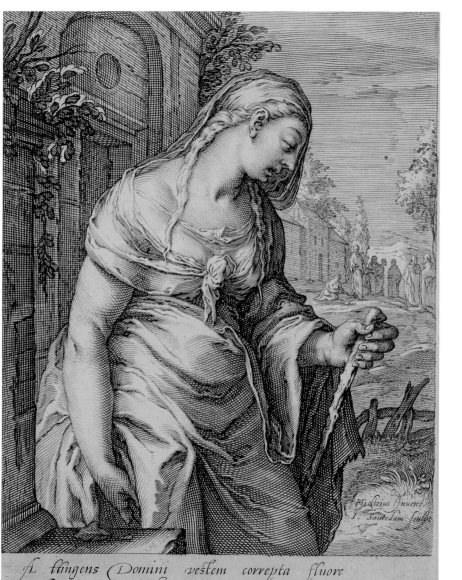

Attingens Domini veſtem correpta fluore
Sanguineo, ſubitam fœmina ſenſit opem Balthaſarus . Schon

H/Goltzius Inuent.
I. Sauredam ſculp

The Crippled Woman

According to the Gospel of Luke 13:10–17, Jesus was teaching in a synagogue, where a woman—crippled by a spirit for eighteen years—was also present. Bent over and unable to stand straight, Jesus saw her, called her forward, and said to her: "Woman, you are set free from your infirmity." He then put his hands on her, and immediately she stood erect and praised God. Although the miracle can be seen in the background, in contrast with the other prints in the series, the woman is shown crippled in the foreground, before rather than after she is healed by Christ.

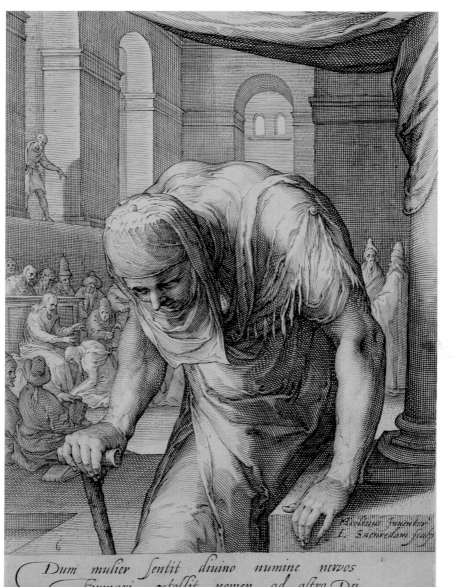

Nicolaus Iuuenior
I. Saenredam sculp.

6

Dum mulier sentit diuino numine neruos
Firmari, extollit nomen ad astra Dei.

Balthasarus Schonaeus

Dangerous Women is published in conjunction with the exhibition of the same name at the Patricia & Phillip Frost Art Museum, Florida International University, February 17–May 27, 2018, and the Cornell Fine Arts Museum, Rollins College, September 8–December 30, 2018.

Text and photography © 2018 The John and Mable Ringling Museum of Art

Book © 2018 Scala Arts Publishers, Inc.

First published in 2018 by
Scala Arts Publishers, Inc.
c/o CohnReznick LLP
10th floor, 1301 Avenue of the Americas
New York, NY 10019, USA
www.scalapublishers.com
Scala – New York – London

Distributed outside of The John and Mable Ringling Museum of Art in the booktrade by
ACC Distribution
4th floor, 6 West 18th Street
New York, NY 10011, USA

ISBN 978-1-78551-119-6

Edited by Eugenia Bell
Designed by Laura Lindgren
Printed and bound in China

10 9 8 7 6 5 4 3 2 1

Front cover: Palma Vecchio, *Herodias* (detail), page 58
Frontispiece: Francesco Cairo, *Judith* (detail), page 54

Library of Congress Cataloguing-in-Publication Data
Names: Brilliant, Virginia. | Dennis, Kimberly L. | Garrard, Mary D. | Patricia & Phillip Frost Art Museum, organizer, host institution.
Title: Dangerous women / by Virginia Brilliant, Mary D. Garrard and Kimberly L. Dennis.
Other titles: Dangerous women (Patricia & Phillip Frost Art Museum)
Description: New York : Patricia & Phillip Frost Art Museum, Florida International University in association with Scala Arts Publishers, Inc., 2018.
Identifiers: LCCN 2017031357 | ISBN 9781785511196 (hardback)
Subjects: LCSH: Women in art—Exhibitions. | Women in the Bible—Exhibitions. | Painting, European—Exhibitions. | Painting—Florida—Sarasota—Exhibitions. | John and Mable Ringling Museum of Art—Exhibitions.
Classification: LCC ND1460.W65 D36 2018 | DDC 757/.4—dc23
LC record available at https://lccn.loc.gov/2017031357